EMBODYING SYMBIOSIS
A Philosophy of Mind in Drawing

AMBER STUCKE

Copyright © 2011 by Amber Stucke

All rights reserved. No part of this book may be reproduced in any form or by any electronic or mechanical means (including photocopying, recording, or information storage and retrieval) without permission in writing from Amber Stucke.

Printed in the United States of America

A M B E R P R O J E C T S
2010 Vine Street, Berkeley, CA 94709
www.amberstucke.com

v

CONTENTS

Introduction: Symbiosis State 1

I Consciousness 7

II Drawing 13

III The Vessel 20

Conclusion: Philosophy of Mind & the Artist 26

Notes 32

EMBODYING SYMBIOSIS

x

INTRODUCTION
Symbiosis State

On rawguru.com, you can buy, for thirty-four dollars and ninety-five cents, a tincture of cordyceps mushroom extract. The listing is stated as follows:

> Organic liquid extract concentrate of mycelium. The pure healing force of the mushroom lies in its mycelium. Mycelia are the delicate life threads growing unseen in rainforest soil and wood, culturing organic matter and delivering probiotic nutrients to all trees and plants. It has maximum healing benefits on our physiologies. It is easy to digest and is rich in potent micronutrients. It contains Glycoproteins, Arabinoxylanes, Ergosterols and Broad Spectrum Glucans.
>
> At least 1,500 years ago, Tibetan herders observed that yaks would eat Cordyceps and then frolic with great energy and "passion." This encouraged the herders to experience the power of Cordyceps, which has led to its use by hundreds of millions of people over the ages. In 1993, the Chinese National Track and Field Team attributed their success in breaking three World Records in part to their use of Cordyceps.
>
> New Chapter LifeShield™ Mushrooms deliver the

profoundly healing traditional mushrooms in their organic mycelial form, easiest to digest and richest in potent micronutrients. They are the supreme expression of mushrooms' protective and healing intelligence and are rich in polysaccharides and B-Glucans. The extract can be consumed directly or mixed into your favorite beverage. Naturally gluten free.

I have taken this mushroom extract every now and then to explore its uses in body vitality. As I take it each time, I think of the story of how the fungus is created, or in some sense evolves. The mushroom is usually found in a warm, wet tropical climate such as the Amazon Rainforest of South America or the Borneo Rainforest of Brunei, Indonesia, and Malaysia. The mushroom is found covering all types of dead jungle insects such as caterpillars, ants, and moths. Once the ant, or insect, comes in contact with the fungus on the floor of the jungle, the spores attach themselves to the external surface of the ant, where they germinate and infect the ant's brain. Disoriented and infected by the cordyceps, the ant steers away from the rest of the other colony of ants and climbs on a plant to reach higher ground. The ant clamps its mandibles down on the leaf or stem of the plant to secure its final resting place. The fungus then devours the ant's brain, killing its host. With the ant dead, it becomes a host body for the cordyceps to fruit from the brain of the ant. The mushroom's intention in using the host to locate to higher ground can be seen as to cover more terrain in spreading the fungus' spores to evolve its species.

 This story takes me back to the cordyceps tincture extract. Under the marketing advertisement description to sell the tincture, it mentions the "mushroom's protective and healing intelligence." I can't help but imagine to myself what the mushroom is doing inside my body while I take it. If it can be understood that fungus has intentions, it can also be understood that fungus has a consciousness. So, by ingesting this mushroom, I wonder how much influence the intelligence of the mushroom has over my body. Cordyceps can be seen as having a parasitic relationship with the host it encounters, but it can also be seen as having a symbiotic relationship with its environment. Fungus, in general, is known for its properties to break down organic matter and rejuvenate

soil. Overall, I believe it is considered a healthy and necessary relationship even if it does kill other organisms for reproduction. From having the knowledge of this type of fungus, my awareness of its intelligence brings me to believe a possibility of having more power over me than I even recognize or understand. If biologically everything that I ingest is having a relationship to my physical body then how aware am I of my own intentions and myself in the world?

With this question, I am opening up the possibility that by ingesting a mushroom extract into my body, it might actually be influencing how and why I am making drawings with fungus in them in the first place. What if my art practice is more than just about graphite on paper or philosophical intentions? What if other consciousnesses from other organisms biologically influence how I communicate imagery through drawings from my body? This is similar to the same kind of question that writer Michael Pollan was getting at in his book, *The Botany of Desire: A Plant's-eye View of the World*. Pollan makes a strong case as to how plants have changed us to help them evolve in the world. He stresses how plants become so compelling, useful, and tasty to human beings that they (the plants) inspired us to seed, transport, extol, and do other important agricultural work to advance their evolutionary path. Pollan's notions of these broader complex reciprocal relationships between the human and natural world intersects with ideas of symbiosis where nature and culture interconnect into a coevolutionary relationship. He explains this concept further:

> Evolution doesn't depend on will or intention to work; it is, almost by definition, an unconscious, unwilled process. All it requires are beings compelled, as all plants and animals are, to make more of themselves by whatever means trial and error present. Sometimes an adaptive trait is so clever it appears purposeful: the ant that "cultivates" its own gardens of edible fungus, for instance, or the pitcher plant that "convinces" a fly it's a piece of rotting meat. But such traits are clever only in retrospect. Design in nature is but a concatenation of accidents, culled by natural selection until the result is so

beautiful or effective as to seem a miracle of purpose.[1]

 Pollan is only one source out of many that propose some clarification of motive to other consciousness beyond my own, whether it be through writing a book or in making a piece of art. Other experts include people such as Terence McKenna, Jeremy Narby, or Donna J. Haraway, who also continue a dialogue on awareness of other intelligence beyond human beings.[2] Each of their research has brought and still brings insight and new conversations on either trans-species communication or plant consciousness. As an artist with curiosity and imagination to explore, I am drawn to investigate how my body experiences and learns from the world around me through drawing. It is curiosity that begins my journey of mind and body (mind-body). This curiosity also leads me to a journey of how my consciousness and drawing have grown together to create an internal state of mind that I call symbiosis state.

‡

 In my work, the act of creation begins with both an idea and a mark on a surface. Although the hand creates the mark that speaks the idea, it is the structure, or the rendering, of the mark that engages the viewer to explore, investigate, and decode the space between subject and object. This is the in-between space that I am interested in creating systems of known and unknown, visible and invisible, rational and irrational, philosophical and biological within drawings. I want to provoke a phenomenological space within the mind-body and guide the observer to connect to the separations and interconnections that I have created in forms to allow the viewer to imagine the possibilities and probabilities along with me. It is within this dynamic layout of unclassified forms that I analyze and organize the world around me to

gain knowledge through drawing structures and relationships as well as to share consciousness. The drawings become a place for discovery and a guided tour into a state of mind, which can become a place to become other consciousness and also a place to learn of being and origins. This is the space where I embody symbiosis.

When I emphasize this in-between space as a place to also become other consciousness, I seek to change this space to eliminate any binary concerns of subject and object. Both subject and object, mind and body, observer and object, rational and experiential systems, human and non-human forms (all organisms), beautiful and grotesque all become one. This in-between space is then the medium (an agency) that binds and creates the transference and formations to create art. The medium becomes the glue for my own symbiotic relationship with graphite and paper; it also becomes the catalyst to travel to a land of other consciousness beyond my own.

Symbiosis, interspecific associations that play a significant role in the evolution of humans, plants, animals, and in shaping of the earth's physical features, originates from a culmination of personal experiences, memories, and awareness that I believe are retained within my physical body.[3] Consciousness is embedded in the entire human body, not just one part. It is because of my belief in how I recognize the mind and body as one and not separate entities, which associates me with a philosophy of mind. From my body, from my hand, I connect to and communicate ideas relating to interconnections between all organisms. I create new relationships and new knowledge systems that explore and analyze the potentialities of the idea of symbiosis. It is not only through the act of drawing that I interact with these ideas and relate them back to the human body in visual art, but it is within these drawings and also within this essay that I bridge the image of contemporary knowledge systems today, back to the image of knowledge structures during The Age of Enlightenment. After each drawing has been created, it becomes a document and also an experience, which is intended to integrate both the image of the rational scientific and experiential knowledge system.

Out of appropriations from visual scientific taxonomies to biological structures of the human anatomy, my interests of systemizations allow me to sustain a conversation between a knowledge structure and an experience. The structure, or system, can define or create exactitude

to an image. However, a system can also transform the familiar image out of the finite and into an encounter of symbiosis. To form a symbiotic relationship, to capture a phenomenological experience is also to document a sense of the unknown. It is this unknown territory, or in-between space, that makes up symbiosis: consciousness, drawing, and the vessel.

CONSCIOUSNESS

 I regularly encounter a man at the tollbooth as I drive across the Bay Bridge. I remember only his face, his hand that gives me my change, and his facial hair that slightly covers a large tumor, or a bulge, growing just beneath his ear. I do not think of this man's identity or his daily struggles, but I wonder about a possible parasite that is biologically lodged within his body that has created this tumor.
 I imagine and transfer myself to become this parasite, which has transformed skin, flesh, blood, tissue, cells, and the form of a body. I also imagine how to transform myself to understand this place of change and a land of other consciousness beyond mine. This image grows in my mind and connects to a chain that links to a symbiotic exchange. It is the volume of the body, the tones in the skin, the texture of the hair, and the edges of the form that create a perception of consciousness. It is this awareness and curiosity of an unknown territory of biological physicality that creates an exploration of mind-body.

‡

 Consciousness is a vessel for sensation and perception to experience the environment and to gain knowledge. With consciousness embedded in the body, also known as embodiment, the idea of symbiosis is already a part of a learned knowledge system.[4] Philosophers, cognitive scientists and artificial intelligence researchers study embodied cognition under the belief that the nature of the human mind is largely determined by the human body. Neuroscientist Francisco Varela has written extensively on this subject through his phrase of *embodied action*. *Embodied* highlights how cognition depends upon the types of experience that come from having a body with various sensorimotor capacities. And second, these individual sensorimotor capacities are embedded in a broadly encompassing biological and psychological context. *Action* is a word to emphasize how the sensory and motor processes, perception and action, are fundamentally inseparable in lived cognition.[5] It is through my embodiment of symbiosis that defines my physical body as a device to gain knowledge from my lived experiences. This experiential knowledge from consciousness is connected to the ideas within phenomenology.

 In his book *Phenomenology of Perception*, Maurice Merleau-Ponty explains how human beings become aware of their bodies for the first time to understand what is true of all perceived things: that the perception of space and the perception of the thing, the spatiality of the thing and its being as a thing are not two distinct problems. The experience of the body teaches people to realize space as rooted in existence. He states how intellectualism clearly sees that the motif of the thing and the motif of space are interwoven, but reduces the former to the latter. He further deduces how the experience discloses beneath objective space, in which the body eventually finds its place, a primitive spatiality of which experience is merely the outer covering and which merges with the body's very being.[6] Within Merleau-Ponty's discussion of the human body, he shows us that the body is not an 'object' in the sense given to this term by objective thought. Its properties are not determinate; its activities defy the empiricist attempt to provide causal explanations which depend upon scientifically testable claims about external relationships. It is through the body's acquisition and exercise

of motor skills, such as using a typewriter, playing a musical instrument, or even creating a work of art, which, for Merleau-Ponty, gives a proper account of knowledge, understanding and intentionality experienced within the physical body.[7] Merleau-Ponty's phenomenology can give meaning to how my body holds memories, experiences, and awareness within my explorations of symbiosis. But if I break down and clarify all of my personal memories, experiences and awareness to an observer, then this in-between space becomes lost. My reasoning would desolve this unknown territory of exploration and creative experience to document, become, and share other consciousness within drawings.

The language that I speak of, and the text that I write in this essay, become part of this disruption and disconnection to the unexplainable–the unspeakable as well. Therefore, metaphor and theory bridge certain understandings–it gives and creates new knowledge of thought-but a philosophy of mind is not actual experience.[8] It can give insight and reflection into practice, but it is the individual body's behavior and interactions that determine experiential interrelationships. Merleau-Ponty furthers this viewpoint; he shows how both science and phenomenology explicated our concrete, embodied existence in a manner that is always after the fact. Phenomenology attempts to grasp the immediacy of our unreflective experience and tries to give voice to it in conscious reflection. But by being a theoretical activity before and after the fact, it does not recapture the richness of experience. It can only be a discourse about that experience.[9] If phenomenology can help me theorize the body in my art practice, it is this practice, the act of creation within art making, which defines how I have come to explore a type of unknown territory and also a philosophy of mind. The act of drawing, the connection from hand to paper gives me self-consciousness. I become aware of my body, graphite, paper, light, the environment around me, and my internal thoughts. As I continue to draw, my conscious experience transforms to a space of consciousness of other (a space where subject becomes object and object becomes subject). This experience becomes trans-special where both human and non-human species coexist.

I not only believe that consciousness is biologically connected to my entire body, but I also believe in other consciousness all around me. All forms of life that I am looking at to investigate the idea of symbiosis, which includes fungus, lichen, algae and parasites, have a consciousness

that can be explored, experienced, and translated. Other consciousness is a part of this unknown territory that I speak of, a place of transformation in energy where molecules and matter exchange and interact beyond the naked eye of visual perception. My self-consciousness instigates my awareness of other beings outside of my body. I see other consciousness of other organisms as cultures yet to be explored. Cultures that are not defined by my Western education, Catholic, Caucasian upbringing, beyond my physical body, instead they are cultures of all forms of life— human, animal, insect, fish, plant, fungus, bacteria, etc. These types of cultures are also determined by behaviors and interactions for means of survival and evolution. All organisms, including human beings, relate on simple notions to evolve, associate, and communicate, but I consider these notions of other consciousness as in-between space as well, an unknown territory. I look to Elizabeth Grosz in pushing these ideas further to describe the act of creation as a form of trans-special communication, which crosses boundaries between self and other consciousness.[10]

Grosz, in her book *Chaos, Territory, Art*, clarifies this understanding of subject/object–self/other interrelationships through an analogy to art. Grosz is not an artist herself, but interprets an experience of art from the words of the French philosopher Gilles Deleuze. She begins with how art is about sensation through a material experience. Grosz translates how the material becomes consciousness through the act of creation. Everything the artist uses for his or her means to express this consciousness melts into one another, where boundaries of subjects and objects no longer exist. It is art alone that can open up an in-between space to be explored and investigated. She further explains the importance of this field along with its future intentions.

> The arts, each in its own way, are not just the construction of pure and simple sensations but the synthesis of other, prior sensations into new ones, the coagulation, recirculation, and transformation of other sensations summoned up from the plane of composition–indeed becoming itself may be understood as the coming together of at least two sensations, the movement of transformation that each elicits in the other. Art is this

> process of compounding or composing, not a pure creation from nothing, but the act of extracting from the materiality of forces, sensations, or powers of affecting life, that is, becomings, that have not existed before and may summon up and generate future sensations, new becomings.[11]

As an artist, I identify with this experience of art. When I create a drawing, I also create a synergy between my consciousness (mind and body), the paper, and matter that exist all around me. This matter is alive and fuses the matter that makes up my body as well as any objects that make up the environment. It is within this in-between space where knowledge, experiences, memories, and awareness exist. It is where art has a place to remind us of others and ourselves in the world, and a place to share this consciousness.

 The human imagination is just as powerful as a destructive hurricane, the force of a devastating earthquake, or even a fierce tsunami. For French philosopher Gaston Bachelard, the true voyage of the imagination is the journey to the very domain of the imaginary. In the realm of the imagination, every immanence takes on a transcendence. The infinite is the realm in which creativity is affirmed as pure imagination, in which it is free and alone, vanquished and victorious, proud and trembling. There the images take flight and are lost, they rise and crash into their very elevation. The imagination becomes a psychic forerunner which projects its being.[12] Imagination can and does transform consciousness everyday. It is its own agency within consciousness, sensation and perception, and matter. It is also a tool to gain knowledge of the world and to make sense of it. It is with my imagination I begin to draw.

DRAWING

As the rainy season begins in Northern California, I become more aware again of the lichen in my environment; how it sits on top of my neighbor's fence, how it straddles parts of the stairway to my apartment, or clings on the rocks in the forest preserves that I frequent. The invisible lichen during the dry season become visible during the wet season. What seems dead or dormant, out of sight, comes alive and conscious in my mind. The droplets of water awaken the lichen's color, form, and shape—they speak to me; calling to me to listen to them. Enamored by their presence, I begin to imagine what the lichen is trying to communicate to me.

In biology, lichen is the purest form of a symbiotic relationship. It is a new species created from the marriage between fungus and algae. Lichens grow practically everywhere—on and within rocks, on soil and tree bark, on almost any animate or inanimate object. They have been found on the shells of tortoises in the Galapagos Islands, on large beetles in New Guinea, and in the dry valleys of Antarctica. Known as perfect bioindicators in the environment, lichens sensitivity to atmospheric pollutants such as sulfur dioxide, ozone, and fluorides has made them valuable indicators of pollution in cities and industrial regions.[13]

‡

 Lichens cannot exist without the rock, the branch, the fence, or the wood stairway. It forms a relationship with the present object, just as fungus, algae and parasites do. I imagine these objects as vessels to learn of the interrelationships formed between the lichen, fungus, algae and parasites. I want to become the vessel and the symbiotic organisms that organize together to understand, imagine, and explore the behaviors of symbiosis. To become is embodiment; it is to embody all knowledge, sensation, experience, and memory through consciousness. To draw is to research this consciousness; it becomes both poetic and scientific. Under symbiosis, I imagine my own interrelationship by creating an open-ended idea of a vessel form. I do not imagine it as an inanimate object, but a living organism–a body of nature. I not only want to become the organisms that I create, but I want to make them come alive–to have energy and electricity to communicate this unknown territory without words. I begin with the vessel form. I draw its individual contour. I place the skin and then the hair–its form is dead until it creates a type of relationship with another living body. As I choose an organism such as cup fungus or red algae to form a connection with the vessel, the relationship can only be established afterwards in terms of logic if it is parasitic, mutualistic, or commensalistic.[14] It is here the electricity comes through my hand to form new relationships and new knowledge systems, because I have no vision or plan of how the form should be created until I choose all of its parts. It is the graphite that becomes the conductor for the electricity to take place on the paper, between the paper and me, and between the paper and the viewer.

 Graphite's properties of carbon layers are known to conduct electricity because of its vast electron delocalization within them. The electricity occurs when the electrons move freely within the plane of layers. It is the movement of the electrons that engage the surface of the paper that enables a dynamic symbiotic relationship to present itself. The symbiosis between the paper, the graphite, and me grows slowly in-between the blank spaces like mycelium under the earth feeding on the plant's roots and also becoming a part of its roots–transforming the root system to an evolved dynamic root that is both plant and fungus. This metamorphosis is also a transformation of the mind. It evolves an

internal state of mind of becoming symbiotic relationships (symbiosis state). To become the represented living body of nature, I become the behaviors of the slime mold, crust lichen, internal parasites, or yellow algae to form a symbiotic relationship with each individual vessel that I imagine and create through graphite. I travel to this unknown territory as I draw through tone, line, form, volume, color, and expression. Somehow, everything connects and translates beyond my own act of creation-beyond my philosophy of mind. It travels to that plane where all planes coexist.

Just as Deleuze and Guattari would explain this idea of becoming, that coexistence is why planes may sometimes separate and sometimes join together—this is true for both the best and the worst. They have in common the restoration of transcendence and illusion but also the relentless struggle against transcendence and illusion; and each also has its particular way of doing both one and the other.[15] It is here in this unknown territory of coexistence where I want to become, or embody, the idea of symbiosis to experience and remind myself of knowledge that is not language or text. It is also the place where I want to translate and communicate the sensations, experiences, and perceptions of my consciousness to others to share my knowledge of symbiosis beyond words. This kind of drawing practice is where intensities proliferate, where forces are expressed for their own sake, where sensation lives and experiments, where the future is affectively and perceptually anticipated. The drawing process becomes where properties and qualities take on the task of representing the future. It is where consciousness sets out not only the possible becomings of a subject-in-process but also the possible becomings of peoples and universes to come. It is the possibility of the creation of new worlds, new knowledge systems, and new peoples to live and experience them.[16]

If art has the power to transform experience and perception in the minds of other people, then I believe this is where drawing can have a type of scientific method within artistic research. Drawings can be based solely on aesthetic formal qualities present in the image, but it is the intention that can reveal layers of intensity and move beyond just the image present on the surface. Research is connected to this intensity in art marking. It emphasizes the development of a method or system to explore or interpret information. This process of drawing for hours

to achieve a state of mind of symbiosis–to become the behaviors of living organisms in the environment–is a systematic investigation to gain knowledge. The drawing process becomes a creative methodology to learn interconnection, to create new forms, and to learn new systems. Without a specific scientific method, it does not hold up against empirical research, but it can communicate aspects of unknown territory in the mind-body connection. It can open pathways for new understandings in consciousness studies and also allow for renewal of ideas in reflection and contemplation in human experience.

<u>My Drawing Method Includes:</u>
Subject/object specifications
Formal layout appropriations
Vessel structures
Mutualistic, parasitic, & commensalistic relationships
Detailed, descriptive observations
Imagination
Open-ended texts

Just as described in evolutionary biology, it is only by nature that the human body wants to relate, communicate and evolve like all other species. I want to emphasize this knowledge through a drawing process within my investigations of symbiosis. The concept of symbiosis has been applied to human affairs in which cooperation and mutual aid have been the principal forces of evolutionary change. The importance of studying symbiosis in biology is underscored by the increased ability for scientists to control pathogenic organisms by understanding the molecular mechanisms of biological interactions.[17] This knowledge in science is under-recognized and under utilized but can thrive in a philosophy of mind and in art. The relevance in having creative methods of documenting in-between spaces of subjects and objects allows for the human body to become the device for a local knowledge system to thrive. It is the systems that we create that influence the images in

our mind to understand and believe the classifications, taxonomies, topographies, encyclopedias, and dictionaries that have become the references of libraries. It is also the system that somehow motivates the drawing to exist and enables a relationship to occur. I take in this system with curiosity and sensitivity and explore how knowledge structures are only a vessel to learn of others and ourselves in the world.

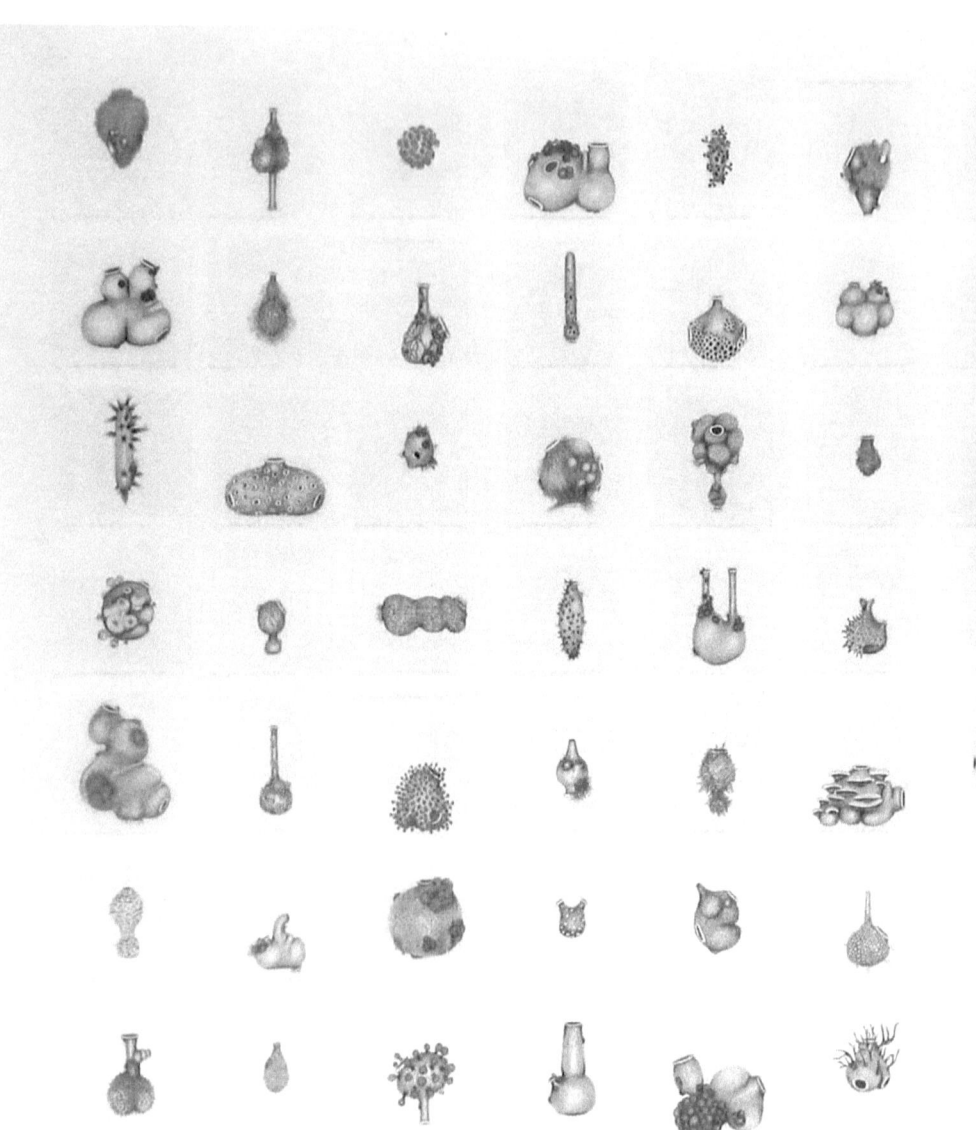

Amber Stucke, *Various Species of Behavioral Vessels (Symbiosis State)*, 50"x82"(hxw), 2010.Graphite, Ink & Gouache on Stonehenge Paper. First drawing in symbiosis state exploration. There are 91 smaller drawings within it. Please visit my website www.amberstucke.com for better quality images.

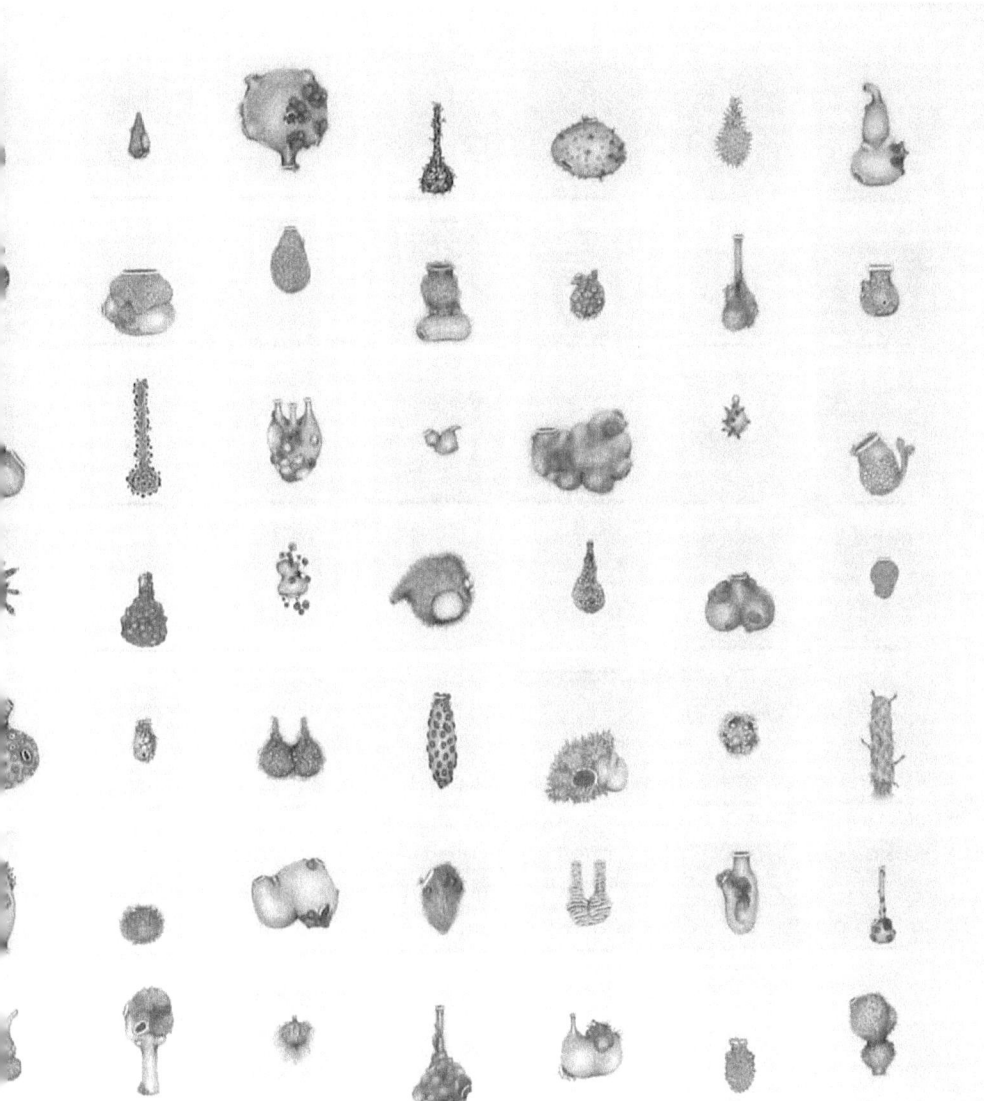

THE VESSEL

III

 During my young adulthood, I had a dream about my step-grandfather on my mother's side of the family. I was at his wake. He was placed in an open casket for viewing before the burial would take place. As I walked up to the casket, I knew it was him. I remember only the event of the funeral and not the emotion of the situation; I then woke up. He was alive at the time of this dream. Several months had passed, and then there was a phone call to my mom that my step-grandfather was placed in the hospital for treatment of emphysema. A month after he was placed in the hospital, he died. Yet again, I was at his funeral but this time it was not a dream. I never told my mother about this experience.

 I perceive my physical body as a vessel and also a local knowledge system to share and to document within a drawing process. Its parts consist of flesh, bone, muscle, organs, blood, tissue, cells, and many other components that are known, but still unknown in many ways. I cannot explain the dream of my step-grandfather, for I was never close to him and hardly spent any time together with him. I think of how aware and unaware I am of my body, and how my bodily experience affects every aspect of my day and my life. It is within this body that I experience more than what is known as sensational, I experience more than what I can explain, more than what is considered rational. On the other hand, my human body has many rational, biological experiences and reminds me of my genetic makeup and just how physical and fragile my body

remains as long as I am alive.

Arthritis has been passed down from generation to generation in my family. My grandmother had both osteoarthritis and rheumatoid arthritis. My mother, my aunts, and even my twin sister all have arthritis. I don't guess if I will ever have arthritis, I wonder when and what type I will get in the future. Today, as I wake up in the morning, I can feel stiffness and sometimes pain in my hands and wrists. These are signs and symptoms I need to watch and take care of, to remember what my physical, fragile body, this vessel, can endure.

‡

Art allows me to create specific projects to research, investigate, explore and analyze through a creative process. Visual taxonomies created during The Age of Enlightenment have attracted my eye aesthetically ever since I discovered them in antique stores in the town of Bath, England.[18] Scientific illustration as we know it today originated during this time period. What once were cabinets of curiosities, also known as *Wunderkammers*, became organized and systemized into Linnaean classification systems within the field of taxonomy. Taxonomy is known as the science and practice of classification; it defines an empirical knowledge system used and updated within contemporary science. In my work, I appropriate from these visual taxonomies to create conversations between local knowledge systems of the human body and scientific classification structures. Both the rational and experiential come together to further an open-ended critique of what a knowledge structure is and what it can become. In taxonomy, the separation of parts to a whole and the displacement of form out of context all lead to visual engagement of learning and understanding of life around us. However, in my work, this type of education is juxtaposed with locality and autonomy from personal experience. It is because of this that the art becomes an open-ended idea, a vessel, for unique translation and a guided tour into a state of mind.

It is a hunger for life and a thirst for knowledge that always brings me to ask many questions. My curiosity and imagination are never empty and never quiet; they sustain a collection, a cabinet of memories, experiences, and awareness within my own mind-body. During Renaissance Europe, the cabinets of curiosities included artificial and natural, pagan and Christian, ordinary and exotic artifacts. The elaborate rooms of these strange collections demonstrated how we learn painstakingly by gathering and arranging bits and pieces in the dark. There is always more evidence, always another, and better, mode of organization for display. Stray specimens of cultural and natural remains–portraits of historical figures, *trompe l' oeil* still lifes, exotic animal species, scientific instruments, sports of nature, and marvels of metal casting–jostled one another on charged tables and cluttered walls. Instead of concealing the absence of connections, the dynamic layout summoned the observer to fill in the gaps.[19] The learning process for an individual is different for each person; it is subjective in nature to how one utilizes a system to gain knowledge. The gaps between the objects become just as important as in the placement of order. However, visual arbitrariness placed on cultural and biological collections associated with collectors such as Albertus Seba (a seventeenth century Dutch pharmacist and zoologist) only demanded more order and structure for the scientist to be born. It was out of the need for order and expansion of knowledge, where the empirical academic education system began to create structures for learning systems.

In 1735, Carl Linnaeus (a Swedish physician, naturalist and explorer) created a rank based scientific classification system known as the Linnaean taxonomy. His system of genus and species remains the only extant classification system at present that upholds universal scientific acceptance. I am not so much as interested in using the actual structure of Linnaean taxonomy in my work as much as I am interested in using the visual format for separating relationships between living things to create new ones. The idea of separation is unique to rational and analytical knowledge systems. To take parts and place them in systematized arrangements allows for archives, catalogs, encyclopedias, and dictionaries to prevail. The critique of this education model is that it is an outdated system, which needs to be reunited back to the whole, or entire ecological structure, and within its context. On the other hand,

the scientific mind is just as important in the use of separation as in the experience of body sensation. Together, they form a new knowledge system with open-ended intentions to both experience and education. This idea of educational, material sensationalism relates to The Age of Enlightenment pedagogical thought. During this time period, it was expected of the observer to explore unexamined intellectual documents of scientific illustrations to not only challenge people's insightful abilities but to also feed their visual curiosity.[20] It also correlates to the expansion of knowledge through interdisciplinary education, the invention of the print, an emphasis on humanity, and an understanding of reasoning versus faith-based thought. For instance, Genenvan biologist Charles Bonnet depended upon a kind of material sensationalism within his education model in science during the 1700s. For him, learning was tied to the reproduction of images and the multiplication of motions in the sensorium. He reasoned how constant brain stimulation from observations of external impressions was essential to the generation of ideas.[21] Sensation and perception are intertwined into experiential knowledge gained from human bodily experience. Bonnet connected to people's bodily experience in learning situations; he knew that order and display needed more than just a system in place to attract visual imagery necessity. I too find that a familiar system can be utilized to share intellectual thought, biological experiences, and consciousness. It is the experiential knowledge system that brings me to look closer at the local knowledge structure.

 Local knowledge generally refers to long-standing traditions and practices of certain regional, indigenous, or local communities. It can also be related to folk taxonomies, which are vernacular naming systems created from the way people make sense of and organize their natural surroundings around them. Similarly, the human body has biological practices such as producing white blood cells on a day-to-day basis, or regulating heart rate, digestion, respiration rate, salivation, perspiration, urination and sexual arousal through the body's autonomic nervous system. From this perspective, the body too is always placed within a specific region or local community for some period of time. Consciousness reflects this placement and bodily experience within the consideration of a local knowledge system. The body has specific and individualistic experiences to a person's situation, environment, and

human relations. The personal experiences become an act of autonomy, which make everything local.

 Taxonomies originated out of folk biological classifications, which have been forgotten and displaced along side the knowledge systems of today. Scott Atran, an American/French anthropologist, validates this point, disputed among the scientific community. In his book *Cognitive Foundations of Natural History: Towards an Anthropology of* Science, he explains how:

> The significance of folk ways of thinking about the living world to the development of systematics is not limited to the elaboration of those cognitive susceptibilities that helped to shape the *scala naturae*, namely, concern with a visible order of things and a focus on man as the standard of comparison. A more direct influence of folkbiology on science, and one whose effects have lasted to the present day, pertains to a *basic common-sense disposition* to apprehend and order discontinuity in the living world. The very notion of an absolutely ranked taxonomy sprouts from conceptual schema that are at the root of the layman's belief in a natural hierarchy of groups within groups.[22]

Atran speaks of the experiential and common sense, everyday lived world knowledge, which has no natural hierarchical system. The structure is placed within the interrelationships of all organisms and not by the pyramid format. My investigation of symbiosis explores this local knowledge system inside of me. It is how I have come to create the idea of the vessel in my work.

 In my drawings, I create the imaginary vessel as an open-ended idea connected to my explorations in embodying symbiosis. I invented it to form new relationships and new knowledge systems to be experienced. Its origins stem from a need for a visual structure to learn of other consciousness and myself in the world. The vessel acts as a living foundation for a symbiotic growth to occur. It is a structure related to

the human body and also to a body of nature; it is alive and animate. It is also a structure of becoming known and unknown possibilities in relationships as a means of describing our evolutionary biology. The vessel exists in this unknown territory; it interconnects both nature and culture.

CONCLUSION
Philosophy of Mind & the Artist

 The northwest coast region of California is home to the world's tallest trees: the redwoods. Some of these living trees have been alive for over two thousand years. I visit these impressive redwoods at least once or twice a year to remind myself of how little knowledge that my body can hold within my lifetime. It reminds me of the length of time a physical human body can actually exist.

 To this day, it is documented that the oldest person in the world lived to the age of one hundred and twenty-two. It appears to be a long time for a human body, but it is a very short life compared to two thousand years. When you stand next to an old growth redwood tree, the experience is beyond you. At a height of over three hundred and fifty feet tall with a base as giant as a small cottage house, I am in awe of its presence. I am reminded of just how small I am in the universe. I think of how one of these redwoods has lived before the collapse of Egyptian culture, through battles and wars, hurricanes and floods, agriculture, capitalism and the Internet. It becomes a vessel that marks the test of time and encompasses a knowledge system indescribable to my own. Even if I feel disconnected by my thoughts of this tree, I know somewhere, somehow inside myself that it's biology relates to my DNA. This relation crosses paths and time dimensions in a plane of coexistence and into unknown territory.

‡

 My philosophy of mind in drawing is how I embody the idea of symbiosis. I utilize this philosophy to encapsulate how I explore and investigate the nature of mind by looking at consciousness and its relationship to the physical body through a creative drawing process. My work connects to a philosophy of mind because of my belief in how I recognize the mind and body as one and not separate entities. This philosophy can also translate to a state of mind that is determined by specific perceptions and patterns of behaviors. I have come to decipher this state in looking at symbiosis as symbiosis state. It is a state that motivates my drawing method, my learning process, and curiosity of the unknown, which can harness experience and information. Autonomy used by the artist embraces these understandings. This perception of free will and self-governance understood within autonomy can drive a vision to create a shared experience.

 As the artist, I have presented a space to explore interconnections between consciousness, evolutionary biology, philosophy and the imagination. I have opened new possibilities and probabilities in how to look at and think about something in plain sight. I also hope to have brought the observer closer to think about his or her own bodily experience in their everyday life, along with creative formats for research and investigation. By exploring knowledge systems of consciousness through art, I believe humans can open up new pathways for education and also renew ideas within reflection and contemplation in human experience. Nonetheless, there are questions towards my art practice that ask what really makes my drawings considered art, or furthermore, what makes my drawings considered scientific documents to learn knowledge from? Where is my work placed within interdisciplinary thinking in the art and science world? It is because of the specialization of established institutions of knowledge where this topic is divided between discourses. Artwork cannot be considered as a valid knowledge system to an empirical academic institution, because they have not created a system to recognize it along side already established structures. In any case, because I proclaim my drawings as documents of local knowledge from the human body, the work becomes a creation of art, which is established from the autonomous ideas held by the artist.

So, if my work can be considered a work of art, I then ask myself if my work can also then be seen as a tool for alternative education? This question connects to ideas placed within artistic research, which cross disciplines to open critical dialogues and utilize visual intentions for educational purposes. Maybe the Italians seem to be ahead of me on my thinking.

In December 2010, NABA (Nuova Accademia di Belle Arti Milano—one of Italy's largest private academies) launched a project titled "Learning Machines. Art Education and the Production of Alternative Knowledge." The project consisted of a symposium, an exhibition, a temporary library, and a publication, which opened up a discussion on the relationship between art and education, between institutional and non-institutional practices. NABA was the first private art Academy in Italy founded by artists in order to oppose the rigid structure of the official Academy. Its intentions are to integrate education, research and production to foster a cross-disciplinary, intercultural and socially responsible approach to education and artistic production. This project and type of academy answers some of my questions that could possibly give a foundation to my current work, but I am also curious to understand how this project has relevance in the American art education system.

To bring you back to ideas in consciousness, I ask you to think about mycelium (thread-like branches connected to fungus). In a Michigan forest, there is a fungus that is considered to be one of the largest and oldest living organisms on planet earth. The underground mycelium of this fungus stretches for thirty acres, weighs more than ten tons, and is estimated to be fifteen hundred years old.[23] A fungus this successful and versatile goes beyond evolutionary biology; it has a mind of its own. The consciousness of this fungus might just become our future bio-Internet system. Mycologist Paul Stamets articulates this point of view of a possible and probable new knowledge system from mycelial networks. He professes:

> …that mycelium operates at a level of complexity that exceeds the computational powers of our most advanced supercomputers. I see the mycelium as the Earth's natural Internet, a consciousness with which we might be able to communicate. Through cross-species

> interfacing, we may one day exchange information with these sentient cellular networks. Because these externalized neurological nets sense any impression upon them, from footsteps to falling tree branches, they could relay enormous amounts of data regarding the movements of all organisms through the landscape. A new bioneering science could be born, dedicated to programming myconeurological networks to monitor and respond to threats to environments. Mycelial webs could be used as information platforms for mycoengineered ecosystems.[24]

If Stamets can lay out new possibilities to understand the information around us, why can't artists raise the bar in thinking about new formats for learning as well?

I think back to the tincture of cordyceps fungus or even to the mycelium growing in Michigan. Why is it that humans feel the need to claim that we think we know everything? Or, why is it so impossible to have unknowns placed all around us in our everyday lives? Primarily, most people do not think about fungus. Growing up in the Midwest, mushrooms are seen as non-nutritional, poisonous, strange, non-tasty, useless, grotesque forms in nature. Overlooked and misunderstood, fungi are still placed today in an unknown territory of knowledge. However, if we go back and spend some time with the Chinese National Track and Field Team who have taken cordyceps or even just hanging out in the Michigan forest where the mycelium lives in the vast underground, I am positive our bodies would pick up a different sensation from the environment around us or even a different relation to the other person's body next to us. It would allow for a phenomenological experience and also bring us closer to a symbiotic relationship. The bio-Internet could exist within this experience.

Just as much, art allows for many unknown territories. I relate this understanding to the misguidance of my visual perception. I know that my human vision is limited to how I consider my reality. Technological devices have given us insights into what the human perception cannot perceive, but its detectors and sensors still cannot absorb the vast

amount of information all around us. I place this perception back to our free will as human beings and to what we think we know and understand in the world we live in. How much free will do I really have as a human being and as an artist? Cognitive scientists seem to discuss this question, but where do critically creative people come in? In art, my autonomy blends back into subject and object integration. This in-between space, or unknown territory, becomes the symbiosis that allows for these questions and conversations to survive.

NOTES

1 Michael Pollan, *The Botany of Desire: A Plant's-eye View of the World*, (New York: Random House Trade Paperbacks, 2001), xxi.

2 Terence McKenna was an American writer, philosopher, and ethno botanist who advocated the use of plant-based psychedelics as a means of increasing human consciousness and evolution. Jeremy Narby is an anthropologist and writer who examine consciousness, indigenous knowledge systems and the utility of Ayahuasca in gaining knowledge. Donna Haraway is a distinguished Professor Emerita in the History of Consciousness Department at the University of California, Santa Cruz. Haraway writes on trans-species communication and continues a dialogue on the potential between cross species mutality.

3 Vernon Ahmadjian and Surindar Paracer, *Symbiosis: An Introduction to Biological Associations*, (New York: Oxford University Press, 2000), 13.

4 Embodiment refers to the notions within the study of embodied cognition.

5 Francisco J. Varela, Evan Thompson, and Eleanor Rosch, *The Embodied Mind: Cognitive Science and Human Experience*, (London: The MIT Press, 1991), 172-173.

6 Maurice Merleau-Ponty, Phenomenology *of Perception*, (New Jersey: The Humanities Press, 1962), 148-149.

7 Aron Gurwitsch, *Phenomenology and the Theory of Science*, ed. Lester Embree (Evanston: Northwestern University Press, 1974), 162-163.

8 Philosophy of mind studies the nature of the mind, mental events, mental functions, mental properties, consciousness and their relationship to the physical body, particularly the brain.

9 Francisco J. Varela, Evan Thompson, and Eleanor Rosch, *The Embodied Mind: Cognitive Science and Human Experience*, (London: The MIT Press, 1991), 19.

10 Elizabeth A. Grosz is an Australian feminist academic living and

working in the USA. She has mainly written on questions of corporeality and their relations to the sciences and the arts.

11 Elizabeth Grosz, *Chaos, Territory, Art: Deleuze and the Framing of the Earth*, (New York: Columbia University Press, 2008), 75.

12 Gaston Bachelard, *On Poetic Imagination and Reverie*, (Indianapolis & New York: The Bobbs-Merrill Company, Inc., 1971), 22-23.

13 Vernon Ahmadjian and Surindar Paracer, *Symbiosis: An Introduction to Biological Associations*, (New York: Oxford University Press, 2000), 112.

14 Parasitic, mutualistic and commensalistic are three types of symbiotic relationships described under the study of evolutionary biology. Parasitism is an understanding of one organism surviving off of another organism. Mutualism is an understanding of two organisms mutually benefiting from one another. And, commensalism is an understanding of one organism living with another organism but not harming or benefiting the other organism.

15 Gilles Deleuze & Felix Guattari, *What is Philosophy?*, (New York: Columbia University Press, 1991), 59.

16 Elizabeth Grosz, *Chaos, Territory, Art: Deleuze and the Framing of the Earth*, (New York: Columbia University Press, 2008), 78-79.

17 Vernon Ahmadjian and Surindar Paracer, *Symbiosis: An Introduction to Biological Associations*, (New York: Oxford University Press, 2000), 229.

18 According to the Stanford Encyclopedia of Philosophy, The Age of Enlightenment is the period in the history of western thought and culture, stretching roughly from the mid-decades of the seventeenth century through the eighteenth century, characterized by dramatic revolutions in science, philosophy, society and politics; these revolutions swept away the medieval world-view and ushered in our modern western world.

19 Barbara Maria Stafford, *Good Looking: Essays on the Virtue of Images*, (Cambridge: MIT Press, 1996), 34.

20 Barbara Maria Stafford, *Good Looking: Essays on the Virtue of Images*, (Cambridge: MIT Press, 1996), 190.

21 Barbara Maria Stafford, *Good Looking: Essays on the Virtue of Images*, (Cambridge: MIT Press, 1996), 187.

22 Scott Atran. *Cognitive Foundations of Natural History: Towards an Anthropology of Science,* (Cambridge: Cambridge University Press) 253.

23 Vernon Ahmadjian and Surindar Paracer, *Symbiosis: An Introduction to Biological Associations,* (New York: Oxford University Press, 2000), 89.

24 Paul Stamets, *Mycelium Running: How Mushrooms Can Help Save the World,* (Berkeley: Ten Speed Press, 2005), 8.

Embodying Symbiosis: A Philosophy of Mind in Drawing by Amber Stucke. A Project Presented to the Graduate Faculty, California College of the Arts. In Partial Fulfillment of the Requirements for the Degree Master of Fine Arts.

Approved:

Jovi Schnell (Main Advisor)

Vivian Bobka (Thesis Advisor)

Ted Purves (Graduate Program Representative)

_____**date**

www.ingramcontent.com/pod-product-compliance
Lightning Source LLC
Chambersburg PA
CBHW021930170526
45157CB00005B/2266